Also by Kate Fox

The Oscillations
Where There's Muck There's Bras
Bigger on the Inside

ON SYCAMORE GAP

ON SYCAMORE GAP

Harper
North

HarperNorth
Windmill Green
24 Mount Street
Manchester M2 3NX

A division of
HarperCollins*Publishers*
1 London Bridge Street
London SE1 9GF

www.harpercollins.co.uk

HarperCollinsPublishers
Macken House, 39/40 Mayor Street Upper
Dublin 1, D01 C9W8, Ireland

First published by HarperNorth in 2024

1 3 5 7 9 10 8 6 4 2

A catalogue record for this book
is available from the British Library

HB ISBN: 978-0-00-873561-6

Printed and bound in the UK using 100% renewable electricity
at CPI Group (UK) Ltd, Croydon

This book contains FSC™ certified paper and other controlled
sources to ensure responsible forest management.

For more information visit: www.harpercollins.co.uk/green

Latin name: Acer pseudoplatanus
Common name: Sycamore

Foreword

'The tree's been cut down'. When people were sharing the news, it often didn't even need to be said which tree it was. It was known by many names – the Robin Hood tree, the tree at Sycamore Gap, or just 'the tree on the wall'. But whatever name it went by, we all pictured the same tree in our mind's eye.

Like many people, I instantly flashed to a memory of when I had last visited. It had been during one of the pandemic winters, edging into spring. I was part of a constant line of North Easterners walking from the car park at Steel Rigg. Reassured by something beautiful that was still there, solid through the turbulent times, quiet, constant and with the promise of green shoots.

When I was asked to write about the tree for this book, I knew it had to be hopeful. Even as the unfathomable vandalism was still raw. It turns out that the hope isn't just in the new growth the tree and its cuttings are sprouting. But in the wider conversations that it is helping to spark. Conversations about conserving the habitat around the wall and everywhere else. About the urgency of this. About how communicative the networks of plant life are – something which is now understood

more widely thanks to popular books like Peter Wohlleben's *The Hidden Life of Trees* and Merlin Sheldrake's *Entangled Life*.

It felt natural to tell a story of the tree in a form which echoes the oral storytelling songs and poems known as the Border Ballads, written in the area between the 1300s and 1600s, when stories of cross-border raids, rebellions and family feuds dramatised the turbulent history of the boundary between England and Scotland where Hadrian's Wall and the tree stood. This 'trunk' of the sequence is interspersed with 'branches' in contrasting forms such as haiku, sonnets and a palindromic poem, showing the tree through the ages, and a chance for us to listen to the tree speak from a perspective deeper and wider than all the stories humans have given to it.

It is clear to me that the tree was a potent symbol of beauty, growth and love, in a time crying out for positive icons. By actively keeping on making meaning, memory and, yes, having those pilgrimages and picnics there, I hope we can let it still stand in our minds, as it once did in the earth, as a positive symbol – maybe even more valued than it was before.

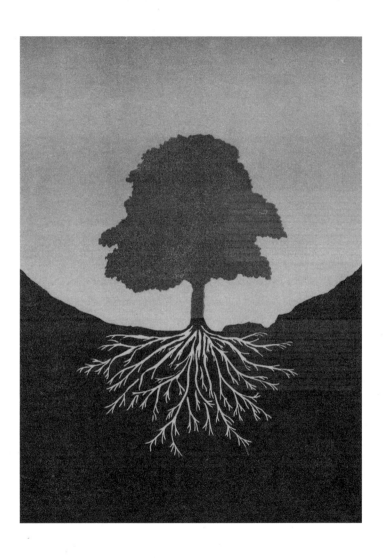

1

In the land of far horizons
where stonechat flit and curlews cry
branches bare and branches green
against a scudding sky.

Where a grey wall is living history
where Romans and shepherds made their home
where a reaching Empire rose and fell,
where dolerite became limestone.

Where a town clerk planted a tree
that would become famous everywhere,
where walkers eat Kendal Mint Cake
where the wind whipped Kevin Costner's hair.

It was a particularly shapely sycamore,
growing sole and full tall
and for decades it was a local way marker
known as the tree on the wall.

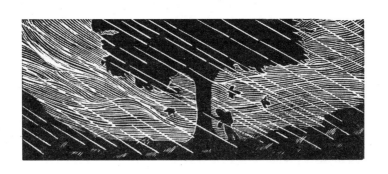

A hiker might rest against its trunk
or touch their hand to its grainy bark,
recognising a companion loner
on the moor in the gathering dark.

We felt it had always been there,
we thought that it always would,
as constant and changing as a Northern Star
or the legend of Robin Hood.

ON SYCAMORE GAP

To say 'There once was a -'
makes it sound like it has gone
but this is the tale of a tree
that was felled and still lives on.

In memories, stories and images
that will keep on being unearthed
in seedlings thriving under glass,
in roots that can be rebirthed.

After Briggflatts

(a poem by the Northumbrian modernist poet Basil Bunting)

Seek, harsh buzzing drone.
Vibrato in Whin Sill's chorus,
each stone a note
in the wall's symphony.
Swoop brave dippers
brown flash on grey.
Unrecorded and modest
arrows firing
before sunlight's flight.
Zoom on the wall's shade
and over the Lough.
Stream fills with eyes
closed only by dark skies.

2

A sycamore which came to fame in a Hollywood movie,
framed by a cinematographer's eyes
sometimes it takes an outsider
to really look and recognise

a beauty hidden in plain sight,
a motif of simple perfection
this single tree between two ridges
this symbol of protection.

and British folk could roll their eyes
at the misplacing of the wall and Sherwood
'Give over! We're nowhere near Dover!'
and feel relieved at knowing where they stood.

And when the Sheriff's men raised an axe
it was then just a fictional threat,
the bad guys wouldn't follow through
for thirty-two years more yet.

A child's drawing of a tree,
two brown sticks and a fuzzy green cloud
continuity lending a sense of safety,
a resilience which made us proud.

This sentinel of nature's majesty,
staving off industry's threats to the land,
thriving in inhospitable soil,
unfussily making a stand.

Kate Fox

Evoking Albion and Avalon,
the wreathed head of the ancient Green Man,
foliate and fertile and magnificent
in its verdant coronal span.

Just close your eyes whenever you need
to summon again those starry nights
that soulful silhouette ready to bust a move
under the disco ball Northern Lights.

ON SYCAMORE GAP

Haiku

Our first map reading.
Next time we come there'll be leaves
Your hand on my back

Filling both our flasks.
Brown blossom falls on your cap,
a laughing selfie

Tease your breathless walk
throwing helicopter seeds.
A ring? Oh! A ring

Yellow sky, blue cagoules.
Crunch underfoot. Touch the bark,
stroke my belly

Kate Fox

One more ring a year
we fill a whole car this time
sky seen through branches

Stare at our photos,
Sudden felling, exposed heart
How is it not there?

Buds stopped in shock
even the light has gone strange
pause like a held breath

Just me in the gap
seedlings elsewhere are growing
I can feel the green

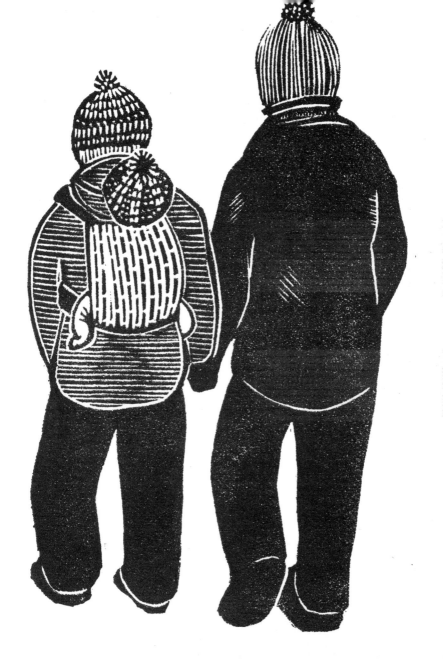

3

They call him The Man Who Saved The Wall*,
but he was also an antiquarian who knew
how to cultivate a wild landscape
and shape Sycamore Gap's iconic view

John Clayton shared it with the world
knowing he would never see
the fruits of his labours beyond his death,
the final flourishing of his tree

John Clayton grew up at Chesters Roman fort on the wall. He bought up and excavated substantial portions of the wall between 1840 and his death in 1892 in order to stop it being built on. He is also thought to have planted the tree, which makes it somewhere between 150 and 190 years old.

ON SYCAMORE GAP

This unmarried man might have imagined his progeny
as a sanctuary for larks and for owls
but not as a global superstar
adorning calendars and tea towels.

In a frontier fort he excavated,
the words Tempore Arboris Resurget -
the tree will rise again. It has before,
do not forget.

Kate Fox

Because the veil is thin for those who watch
at dusk on Castle Nick,
a Centurion hefts his shield,
an archaeologist strikes their pick

Which echoes to the depths of the coal seams
hewn by miners further along time and the Sill,
who knew that exploiting buried treasure
can impact for good or for ill.

Coal's dead tree stuff releases carbon
which vegetation can capture and store.
One day we will owe our lives to the saviours
of the riches of peat, wood and moor.

Kate Fox

The past is more than its objects
Like firedamp it rises and seeps
and one way to understand a society
is through what it loses and what it keeps.

Kate Fox

Mithras

Bull's throat cut
to flood the earth in red.
Sun runner, light maker, giver of fire
chases to the edge of Empire.
Wheel turns and turns again,
we are saved, we will rise.
Mithras* and Sol feast
the lion headed man,
wreathed in snakes,
thunderbolt on his chest
makes the dead live.
A God is born from an egg.

*John Clayton's excavations uncovered a Temple for the mystery
cult of Mithras. Many high ranking soldiers would have taken
part in the pagan rites involving the sacrifice of a bull.

ON SYCAMORE GAP

I, Litorius Pacatianus **
add a pinch of that God,
sprinkle of this image,
rotate them until they dazzle
and flame like a sun disc.
I know which symbols
will gird my men to risk
the Pictish sword,
believe in the word,
kindle the heat
in the centre of themselves
until it becomes a fire
which can remake the world
or break it.

***An official from Housesteads who is thought to have invented
the particular flavour of Mithras mystery worship undertaken
by soldiers stationed on the wall.*
**** John Clayton also excavated an outdoor shrine and well
dedicated to the Celtic-Romano Goddess Coventina at Carraw-
burgh in 1876. She was a rare example of a locally worshipped
deity who was not renamed by the Romans.*

Coventina***

Facing West to sunset, death's door
the triple Goddess nymph
on a water lily, holds wild musk from the moor
tree on her left, flagon in hand.
Coventina, known even by soldiers
thousands of miles from home.
Honoured for her water, her well.
Gratitude carved in stone.

I wish eternal waters
to those who unearth me,
I wish nourishment
to their roots, to their tree.
May their cups overflow,
may their greening shoots grow,
may their inspiration never dry
may my elixir cleanse and purify
the fire, the fear, the knife.
May they never forget the source of life.

4

It was not a gentle time on earth
and the last thing anyone wanted to see
was the shocking gap in the sky that tore
open in September 2023.

A sinking in the chest, a hole,
a wound left exposed, rumours whirling,
senseless destruction all over the news,
the world's darkest shadows unfurling.

ON SYCAMORE GAP

When our security feels threatened
we need more than ever to hold the belief
that the seasons will soothe all sorrows
we can always turn a new leaf.

That day a report was published
while we were still grasping for words –
a sixth of our species in danger of extinction,
drastic declines in animals, plants and birds.*

so this tree can still rise as a symbol,
this tree, this single one
for everything that we are losing
for all the damage that we've done.

The stump, a stoma that can speak of hope
and why we need to trust in our roots,
to keep faith in what is not visible,
just as unseen seeds can sprout new shoots.

Let this tree stand for all the forests
who are thriving or under threat,
and for upholding the new tree charter**
reminding us not to forget

that we can all act as the guardians
of the vitality that exists on this earth
replacing, recovering, replanting
embracing every living being's equal worth.

*The State of Nature report, 2023 published by The State of
Nature partnership
**The Tree Charter of 2017, endorsed by more than 70 organi-
sations, laying out ten principles for a modern day relationship
between trees, woods and people.

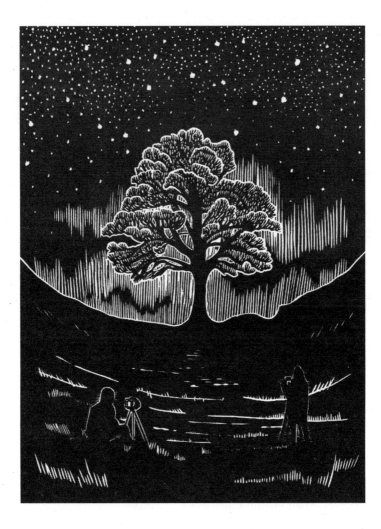

As Above So Below

I was just one tree
Never think that
I was an extraordinary tree
The Tree of Life
I was an ordinary tree
It's not the case that
My roots link me to everything else
In an interconnected system
Like a brain sparking electrical currents
My growth functioned wisely
Like everything else in nature
I am sovereign
So don't believe that
My death will travel beyond itself
That roots are the whole world
As above so below
Fungi, soil, insects, birds know
I was just an ordinary tree
If you look at the world from the bottom up*

*now read the poem from the last line up
** I used Brian Bilston's 'Refugees' as a useful example of an
effective palindromic poem.

172 likes

#sycamoregap
#birthdaywalk
#FREEZING

5

Someone says 'It's sleeping
waiting for the right time to wake'.
People shuffle in and out of shot like chess pieces,
always another selfie to take.

'Do you want a photo with the tree-
I mean stump?' It's an absence that forces you to look,
the afterimage that overlays
every photograph anyone took.

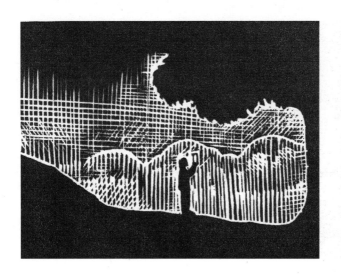

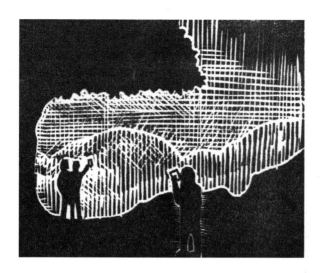

ON SYCAMORE GAP

Clouds swirl forming pictures
between the ground and the sky
pilgrimages of backpackers shaking their heads
asking 'Why, why, why?'

One couple struggle up the hills
say it just felt important to come,
Understatement covering emotion:
'Now back home for a sticky bun.'

Ongoing permission to speculate
because it's not quite a coffin display
'Doesn't look alive to me, like,'
'There's no signs of growth but none of decay'.

Having been with their grandparents and children
some cannot yet face coming back
until time and healing have done their work
and transmuted a presence from lack.

Some note how it was a miracle tree,
a sycamore could never grow here,
a dendrochronology of impossibility
adding another layer every year.

As life itself is against the odds
each unique gathering of cells collected
and formed as a rhizomatic network
holding us inextricably connected.

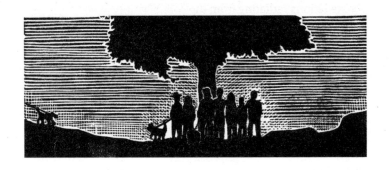

Treow*

Dearest, who we recognise as true,
constellations radiating from the core of you

slowly cycling the seasons of your deep time,
overseeing the speedy passing of our generations

with a constancy unhindered by concern
for your own legacy

we are grateful for the protection of your shade,
for the memories you have made

for the lives tiny and large you have nurtured
from the tips of your laden boughs

to the depths of your mycorrhizal roots.
For the hope you have embodied again and again

in your greening shoots. We are sorry, we are sorry
for your shocks. May we find the will

to properly care for all your kind,
as you in turn have cared for us

may you in future know only peace
may your open heart restore us.

*Treow is the Old English word for tree. It is also the word for true, or vow.

6

Even as Gap
rather than Sycamore
it is somehow as present
as it was before

not just as picture
or as regret
but as buds of new growth
that have more blossoming in them yet

Kate Fox

Nothing's ever forgotten,
nothing is ever destroyed,
memories can be rekindled,
re-lived and re-enjoyed.

There's days out still to come
proposals, picnics and plans
walks yet to be taken
through the breech that it still spans.

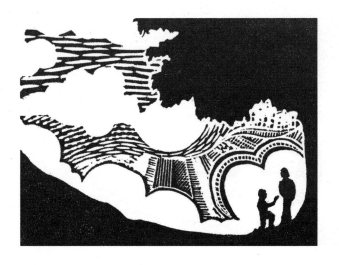

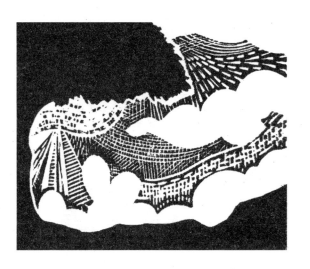

There is the power of intention
following carelessness and slaughter
to bring back the birds
to purify the water.

Dreams yet to manifest
of more regeneration
fuelled by something as real
as wild imagination

to render the opposites
both at once true
something destroyed
can also renew.

There once was a tree
now it is gone
and in more ways than we know
it is still living on.

Acknowledgements

It has been wonderful to be inspired by Cat Moore's stunning illustrations and by generative conversations with her and Genevieve Pegg of Harper North about roots and the Bigger on the Inside-ness of trees. Here's to arborescent collaborations. I'd like to thank all the people I spoke to, and eavesdropped on, at Sycamore Gap. I would also like to thank the Northumberland National Park staff and volunteers at The Sill discovery centre as well as all those from the National Trust and also English Heritage at Housesteads Roman Fort, who do so much as custodians of the landscape all along the wall.

Kate Fox is a stand-up poet, spoken word artist and broadcaster. A regular contributor to Radio 3 and Radio 4's spoken word cabaret *The Verb*, Kate has made two comedy series for Radio 4, been Poet in Residence for the Glastonbury Festival and the Great North Run and completed a PhD in stand-up comedy.

Her poetry collections include *Bigger On the Inside* and *The Oscillations* and her non-fiction book, *Where There's Muck There's Bras*, was based on her sell-out show.

Find Kate online @katefoxwriter
www.katefox.co.uk

Cat Moore is an artist and linocut printmaker, raised in Northumberland but now living and working in Orkney, where her work is inspired by the landscape and folklore of the place.

Find Cat online @catmooreprintmaker
www.catmooreprintmaker.co.uk

Harper North

would like to thank the following staff and contributors for their involvement in making this book a reality:

Peter Borcsok

Sarah Burke

Alan Cracknell

Emma Hatlen

Jonathan de Peyer

Anna Derkacz

Tom Dunstan

Natasha Photiou

Kate Elton

Sarah Emsley

Simon Gerratt

Monica Green

Natassa Hadjinicolaou

Megan Jones

Jean-Marie Kelly

Taslima Khatun

Rachel McCarron

Ben McConnell

Petra Moll

Alice Murphy-Pyle

Adam Murray

Genevieve Pegg

Amanda Percival

Eleanor Slater

Emma Sullivan

Katrina Troy

Daisy Watt

Matthew Richardson

For more unmissable reads,
sign up to the HarperNorth newsletter at
www.harpernorth.co.uk

or find us at
@HarperNorthUK

**Harper
North**